Yoga in Pregnancy and Childbirth

Seema Sondhi

wisdom
tree

Published by

Wisdom Tree
4779/23, Ansari Road
Darya Ganj, Delhi-110002
Ph.: 23247966/67/68

Printed at

Print Perfect
New Delhi-110 064

To My Guru

Acknowledgements

Heartfelt gratitude to my dear friend Christine Sharma, for readily agreeing to lend her support at such short notice. Thank you for helping me materialize my dream of spreading knowledge of yoga to those who seek the wisdom of wellness.

Preface

To become a mother is more than just a wonderful feeling. It is a blessing—a boon the Supreme Being has bestowed upon you. The power to give birth to life and nurture it. You may also feel apprehensive and nervous. In this book you will find a clear elucidation of various exercises, which will prove to be helpful to you throughout this period of nine months.

Asanas will help you remain physically fit. Pranayama proves to be beneficial during this period, as you will be breathing for two. It will also help you to cope well with the painful muscular contractions, which you will experience during your labour. Meditation and relaxation will physically and mentally calm you and help you communicate with your child. Apart from this make sure you eat a balanced diet.

To put it in a nut shell Yoga will help you cope with the stressful months of pregnancy and after the arrival of your baby.

> *'If I'm losing balance in a pose,*
> *I stretch higher and God reaches down to steady me.*
> *It works every time, not just in yoga.'*
>
> —*Bella Convalesco*

Contents

1

The Joy of Motherhood

There is no greater joy known to mankind than that of a mother cradling her newborn in her arms. It is a humbling spiritual experience, a joyous miracle and a triumphant act of procreation. It is the precise moment when a mother knows with complete certainty that this is her ultimate fulfillment.

From that very first magical moment when a woman discovers that she is pregnant, through the time when she feels her baby's first movements, to when she finally gives birth, her body goes through a great many changes. Pregnancy is an amazing journey: a voyage of self-discovery. While the body adapts naturally, her physical and emotional well-being needs careful and tender loving care. Her body is nurturing a new life, and with it comes profound responsibility. Her health, energy, and spirit directly affect her baby.

There can be no other more important time to take care of herself, as when the baby grows within her. Yoga will help her undergo a comfortable and safe pregnancy and delivery, whatever be her health or the circumstances. It will keep her in touch with the changes in her body and prepare her for the challenges of motherhood.

With regular practice of yoga during pregnancy, any woman can avoid physical problems like overweight, stretch marks and backache.

While most of this book is devoted to the practice and benefits of yoga during pregnancy, we have also included a small section for women who are looking forward to getting pregnant. Yoga also helps to facilitate conception, turning anticipation into a joyous reality.

'May the serenity you achieve help you absorb the pure joy of motherhood to the fullest.'

—Yoga Studio

2

Yoga for Health, Confidence and Peace

For those of you first-timers who are contemplating taking to yoga to stay strong and healthy through pregnancy, it is important to understand that yoga is a complete science of life that originated in India many thousands of years ago. It is the oldest system of personal development in the world, encompassing body, mind and spirit. Anyone can practise it, as you do not need special clothes or equipment; all you require is a small space and a strong desire for a healthier, a more complete and fulfilled life.

There are five basic principles of yoga that can be incorporated into your pattern of living, to provide a foundation for a long healthy life.

- *Proper exercise* through yoga postures or *asanas* works systematically on all parts of the body, stretching and toning the muscles and ligaments, keeping the spine and joints flexible and improving blood circulation.

3

- *Proper breathing* to increase your intake of oxygen, recharge your body and control your mental state.

- *Proper relaxation* to release tension in the muscles and provide rest to the whole system leaving you fresh, energetic and most of all, positive.

- *Proper diet* that is balanced, nourishing and based on natural foods to keep the body light and supple and the mind calm.

- *Positive thinking* and *meditation* to help remove negative thoughts and to still the mind.

Even if you have never done yoga before, you will find that practising even the simplest of poses improves your fitness and well-being, while relaxation, breathing and meditation help you handle the whole process, from conception to birth, with greater assurance and calm. All women experience some fear of labour. Yoga practice will not only contribute to an easier labour, but will also help you handle it calmly with deep resources of strength and energy.

'Asanas *make one firm, free from maladies and light of limb.'*
—*Hatha Yoga, Pradipika*

4

Asanas for Pregnancy

*A*sanas exercise every part of the body, stretching and toning the muscles and joints, the bones, the vertebral column and the entire skeletal system. And they work not only on the body's frame but on the internal organs, glands and nerves as well. The *asanas* are designed to release physical and mental tension and liberate vast resources of energy. Yogic breathing exercises, known as *pranayama*, revitalise the body and help control the mind while the practise of positive thinking and meditation encourages increased clarity, mental power and concentration.

Asanas are postures to be held, rather than exercises, and are performed slowly and meditatively, combined with deep abdominal breathing. These gentle movements not only reawaken awareness and control of your body but also have a profound effect spiritually. At the end of every session, you will feel relaxed and full of energy.

We all know that women who are active throughout their pregnancy not only undergo less physical symptoms while in labour, but also recover faster after the birth of their baby. And more

importantly, their babies tend to be healthier and stronger at birth and while in the process of growth.

The yoga postures will help you remain physically fit, give you strength and increase your endurance levels. During pregnancy your physical appearance will gradually change—you will put on weight and your abdomen will expand to accommodate the growing baby. This will put a lot of pressure on your back.

Regular practice of the *asanas* will help ease the stress on your spinal column, tone your internal organs, increase the blood circulation throughout your body and nourish the growing foetus inside your body.

If you have been practising yoga earlier then you should carry on with your practice, but slow down a bit. If you are new to yoga, then the best time to begin is after your first trimester, i.e. the first three months.

> *'But before starting on your yoga programme,*
> *it is best that you consult your doctor.'*
> —*Gynaecologist*

4

Getting Started

Here are some important points that you need to know before embarking upon your practice sessions:

- All that you need for practising *asanas* is your body and the floor, plus a little self-discipline. Choose a well ventilated room, or if the weather is good, then opt for outdoors.

- Try to set aside a special time that you can devote to yourself, free from outside distractions. Ideal time is the evening before eating or else early morning, when your stomach is empty.

- Do get into the habit of doing your *asanas* at the same time each day.

- You need a soft firm mat on which to practise your ground postures. These are easily available at any sports/exercise store.

- Dress in loose, comfortable clothes, preferably cotton, as your body needs to breathe during the sessions. Leave your feet bare, and take off your watch and jewellery.

- Should you feel hot at any time during your class, drink a few sips of water to cool your body down.

- Listen to your body. You are the best judge of what you can and cannot do. Never push yourself too hard; instead work at your own pace. Always come out of an *asana*, if you feel any strain or discomfort. Listen to the signals your body sends you.

- At any point of an *asana*, if you feel breathless, slow down or lie down and relax.

- Avoid all postures that involve lying on your stomach after the first trimester.

- Avoid performing *asanas* lying down on your back, for more than a few minutes This is because as you progress through pregnancy, your growing uterus will put weight on the major blood vessels resulting in decreased blood flow to your heart and uterus. This may cause dizziness.

- All balancing poses are to be done with great care, as your centre of gravity is more forward and upward. Take support when needed.

- Avoid all inverted poses and remember that this is not the best time to learn any new postures.

- Do your postures calmly and gently—avoid rough, jerky actions when you bend, twist and stretch.

- Hold each *asana* for a comfortable three to five seconds, unless otherwise mentioned.

- After each *asana*, relax in *balasana* pose and breathe. Then begin again.
- Modify your *asanas* according to your physical need and capacity. Remember, you must work at your own pace and not force your body to do anything against its capacity.
- Take care not to hold your breath during your *asanas* or *pranayama* practice.
- Last, but certainly not the least, try and rope in friends and do it together or instead opt for a yoga class as this will keep you motivated to continue your practice.

The essence of YOGA lies in four aspects: *asanas, pranayama, bandhas* and *mudras,* as well as meditation and relaxation.

'When you observe that your breath is serene, deep and without any unnecessary pause, you will experience a great comfort and joy.'
—**Swami Rama**

The Sequence of Yogic Postures

When you practise the yoga *asanas*, the pattern or sequence is very important, just as seen in any other form of exercise. During each sequence, the body gets stretched and toned, and each *asana* complements the one executed before. We start with the *griva sakti* or neck exercises, and move on.

GRIVA SAKTI OR NECK ROLLS

The purpose of this set of postures is to release the stiffness and tension in your neck and shoulders, and increase the flexibility in these areas.

- Sit in a comfortable cross-legged position (*sukhasana*) and gently lower your chin down on your chest. Slowly move it backwards as far as it can comfortably go, stretching your neck. Repeat this step five times.

- Next, gradually stretch your neck sideways till your right ear touches your right shoulder. Then bring it back to its normal position. Now repeat the exercise on the left side, till your left ear touches your left shoulder and then bring it back again. Repeat this sequence five times.

- Now you are ready to begin the neck rolls. Lower your head forward and gently drop your chin down on your chest. Slowly rotate your neck in as wide a circle as possible, so that your right ear skims past your right shoulder. Then continue to rotate your head backwards, completing the roll to the left, before ending in the forward position again. Do this five times. Repeat the same sequence in the opposite direction.

- Maintain normal breathing throughout.

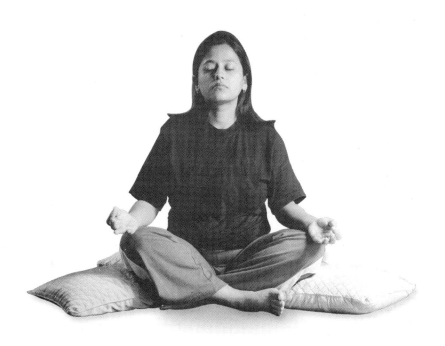

Netra Sakti or Eye Exercises

Like any other muscle, your eyes need exercise if they have to remain healthy and strong. The following exercise will prevent eyestrain and improve your eyesight.

- Sit in a comfortable position. Keep your spine upright and look straight ahead. Without turning your head, start your exercises by first looking up, then looking down. Repeat five times.

- Next, look far right, and then far left. Repeat five times.

- The next set of exercises has a diagonal direction. Look top left, then bottom right and then look top right followed by bottom left. Practise these exercises five times each.

- Look up, direct your vision in a circular motion: first clockwise, then anti-clockwise. Repeat each motion five times.

- Rub both palms together till you feel the warmth in your palms. Place your cupped palms on your closed eyes for a few seconds. Then open your eyes.

- Maintain normal breathing throughout.

15

SKANDA-BHIYA-SAKTI OR SHOULDER EXERCISES

This set of exercises releases the tension and stress from your shoulders, arms and elbows. Continued practice will lead to increased flexibility.

- Seat yourself in a cross-legged position, keeping your back straight.
- Clench your fists and place them on your shoulders.
- Maintaining this position, slowly rotate your arms (elbows pointing outwards) in wide circles: first in a clockwise direction, and then anti-clockwise.

Repeat 10 times in each direction.

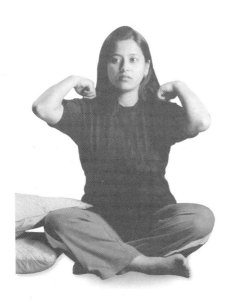 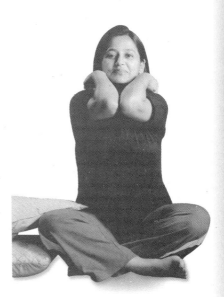

Gulpha Sakti or Ankle Rolls

This is an excellent exercise for tired and weary feet and ankles. It reduces stiffness and increases the blood circulation in your feet. It is especially helpful when your feet and toes get swollen.

- Spread a mat on the floor. Sit on it, keeping your legs stretched straight out in front of you, about 20 cm apart. Place your hands at your sides with your palms flat on the mat. Close your eyes and relax in this position for a few seconds.

- Now carefully lean back slightly, using your arms as a support.

- Rotate your feet from the ankle joint in wide circles, first in the clockwise direction five to ten times, and then the same number of times in an anti-clockwise direction.

- Continue breathing normally throughout.

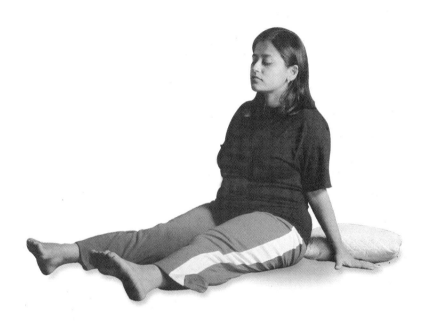

Jathara Parvritti or Torso Side Bends

This set of stretches releases the tension in the muscles of your torso and hips, as these areas are particularly prone to stress during pregnancy.

- Lie down on your mat, flat on your back. Extend your arms outward to your sides at shoulder level.

- Keep your legs resting flat on the floor. Slowly slide your legs one after the other to your right side, gradually turning your head to your left simultaneously.

- Repeat the same sequence to your left.

- Continue this exercise five to eight times on both sides.

- Breathe normally throughout.

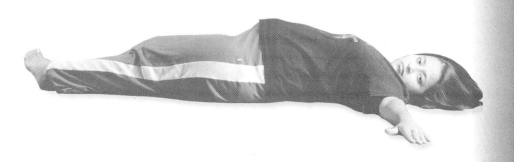

Setubandh Asana or Bridge Pose

This *asana* reduces backache, massages your abdominal organs and aids in good digestion. It is also helpful for women who tend to miscarry. If your baby is in a breech position, regular practise of this *asana* will bring the baby into the normal position for normal childbirth.

- Lie down on your back, keeping your knees bent and hip distance apart. Slowly bring your ankles toward your hips.

- Then reach out for your· ankles and hold them as firmly as possible. In case you have difficulty in holding your ankles, then place your palms on the ground.

- Keeping your elbows and shoulders on the ground, gently lift your hips and pelvis off the ground, lefting from the tail-bone. Keep your entire weight on the shoulders, elbows and feet. Be sure to keep your hip muscles gently contracted.

- Slowly lower your hips.

Repeat 2 to 3 times.

This is a safe asana *to practise during pregnancy, but be careful to avoid over-stretching at any point of time.*

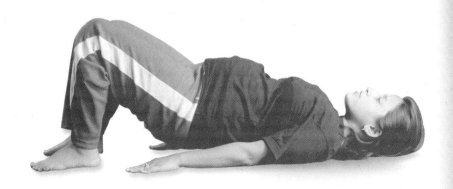

Purvottan Asana or the Inclined Plane

A wholesome *asana*, the 'inclined plane' stretches your entire body and strengthens the torso. It also facilitates expansion of your abdominal muscles, creating space for your growing baby.

- Sit on your mat, with your back straight and legs extended out in front of you. Keep your legs together.

- Gently lean back. Place your palms on the floor on either side of your body, about a few centimetres behind your hips. Your fingers should be pointing away from your body.

- Keep your elbows straight, and your trunk slightly reclined.

- Inhale and gently raise your body upwards. Let your head drop backwards and downwards. Try to place the soles of your feet flat on the ground, by bending the knees.

- Exhale. Lower your hips to the floor.

Repeat the *asana* one more time.

If you are not confident of doing this posture, do not attempt it.

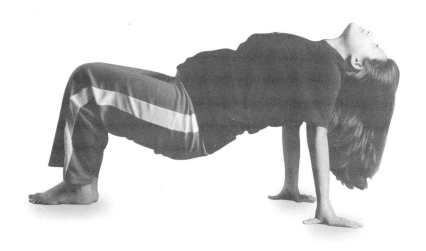

MATSYASANA OR FISH POSE

The 'fish pose' helps to stretch your back and neck. Regular practice reduces throat ailments and improves the skin texture, making you look radiant.

- Lie down flat on your back with your legs straight out. Place your hands and palms underneath your hips and thighs so that you are sitting on them.

- Inhale. Bending your elbows, push away from the ground, lifting your chest until you are sitting half way. Raise your head up and look towards your toes.

- Exhale. Arch your back, expand your chest and lower your head backwards towards the ground. Touch the crown of your head to the ground. Hold this position for a few seconds, breathing deeply.

- To release the position, inhale. Lift your head up and place it on the floor, thus returning to Step 1. Release your arms.

Repeat 2 to 3 times.

This a safe posture to practise all through pregnancy, but take care to keep your movements slow and gentle all the time.

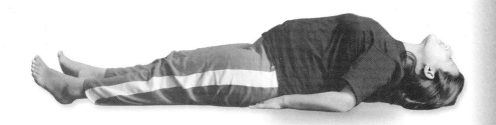

BADDHAKON ASANA OR BUTTERFLY POSE

This *asana* has been designed to improve the flexibility of your pelvic region as it has to bear considerable weight and stress during pregnancy. Regular practice of this *asana* will strengthen the pelvic muscles and prepare you for an easier labour.

- Sit comfortably on the mat. Keeping your spine erect, bend your knees. Join the soles of the feet together and hold on to your ankles or toes for support.

- Gently start moving your knees up and down in a slow motion. This is the gentle motion of a butterfly flapping its wings. Do not flap your knees fast or hard.

As you advance in your pregnancy, sit on a small cushion with your back against a wall.

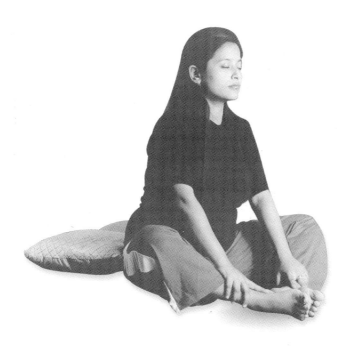

Paschimottan Asana or Forward Bend

This posture releases the stiffness and tension in your back, and makes it more flexible.

- Sit on the mat with your back held erect. Stretch your legs right out in front of you, spread slightly apart. Take a deep breath and 'elongate' your spine.

- Exhale. Bend forward, extending your hands to hold your toes, or any part of your legs that can be reached comfortably. Move slowly without forcing and jerking.

- Inhale and return to the starting position.

Repeat 2 to 3 times.

Take care not to compress the stomach while bending forward.

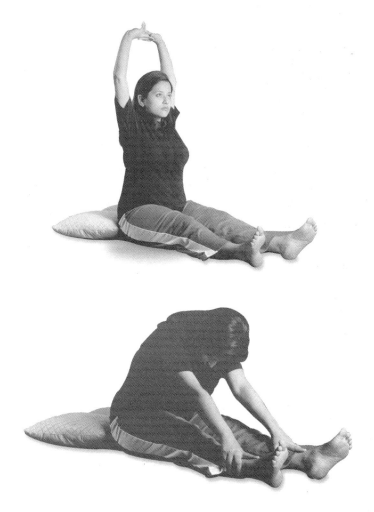

31

Salabhasana or Locust Pose

This *asana* is wonderfully relaxing as it releases the tension in your legs and the lower back.

- Sit on the mat with your hips resting on your heels and knees apart, making space for your belly. Raise your hips and slowly stand on your knees.

- Lean forward and place the palms of your hands flat on the floor. Inhale, lift up your right leg and stretch it out, straight behind you. Exhale. Place the right knee back on the mat. Repeat the same process with the left leg.

- Breathe normally while doing the *asana*.

Repeat 3 to 4 times.

Try not to stretch too much and if you feel uncomfortable doing this asana *after the sixth month, discontinue.*

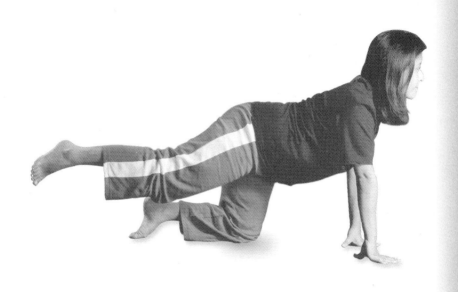

33

USTRASANA OR CAMEL POSE

The 'camel pose', when practised regularly, creates flexibility in your back, and releases the tension and stress from your entire spine.

- Seat yourself on your knees. Then raise yourself up, keeping your knees and feet shoulder-distance apart.

- Support your back with your palms. Inhale and elongate your spine. Exhale. Lean backwards slightly, pushing your hips forward, dropping your head backwards, stretching and expanding your shoulders and chest. Try not to overstretch your spine.

- Release the posture, slowly and gently.

- Breathe normally while holding the posture.

Repeat this *asana* only if you want to.

Discontinue this asana *after the sixth month, if you feel any discomfort.*

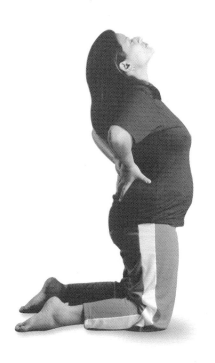

TADASANA OR BALANCING POSE

This *asana* stretches the entire body and increases the flexibility of the limbs. It tones the muscles of your spine, stimulating your spinal nerves.

- Stand with your feet a few centimetres apart, keeping your arms to your sides.
- Inhale. Raise your arms straight above your head. Interlock your fingers stretching the arms, shoulders and the spine upwards.
- Exhale. Release the posture.
- As your baby grows and your abdomen expands, there is a change in your centre of gravity, and therefore you will need to do a modified version of this *asana*.
- Stand against a wall, keeping your feet slightly apart. Your lower back should touch the wall.
- Inhale. Lift your head so as to elongate the spine and stretch your chest and navel.
- Exhale and release the posture.

Repeat 2 to 3 times.

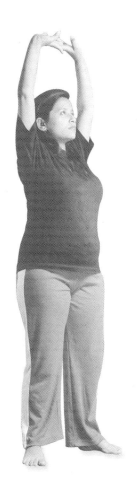

PADAHASTHASANA OR STANDING FORWARD BEND

This *asana* stimulates the spinal nerves, removing the stress from your back.

- Stand with your feet approximately 60 cms apart. Inhale. Stretch your arms way above your head, elongating your spine.

- Exhale. Slowly bend forward and place your palms on your knees. Breathe deeply in this position, and relax your entire body.

- Inhale. Stretch upwards again. Exhale and release the posture.

Repeat two to three times.

When doing this asana, *to accommodate your growing abdomen, you can keep your feet further apart for comfort.*

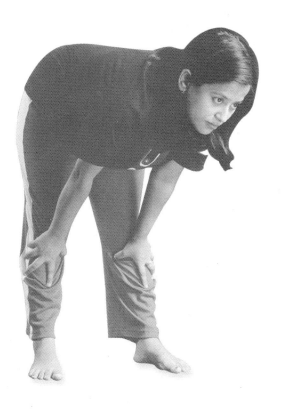

CHANDRASANA OR MOON POSE

The 'moon pose' will reduce the stiffness you experience in your back. Regular practice will help you cope with the physical stress of your womb pressing against your back.

- Stand with your spine erect. Separate your feet, keeping them shoulder-distance apart.

- Place your palms on your lower back to support it throughout this *asana*.

- Exhale. Contract your hip muscles and slowly lean backwards, giving your entire back a stretch.

- Come up and release the posture.

Repeat twice, breathing normally throughout.

If you are a regular yoga practitioner, you should have no discomfort while doing this asana. *If you are new to yoga, be careful not to lean back too much as this may cause you to lose balance.*

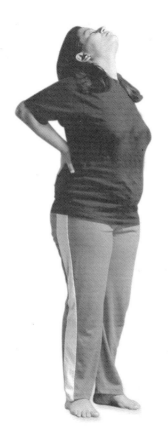

TRIKONASANA OR TRIANGLE POSE

Regular practice of this *asana* tones the hips, back and waist. It also reduces stiffness in the back.

- Stand with your feet 90 cms apart and parallel to each other. Keep your knees tight and pulled up.
- Place hands on your waist to support yourself. Inhale, elongating your spine.
- Exhale. Bend to your right from waist downward. Inhale. Return to your upright position and repeat this step to your left.

Repeat 2 to 3 times.

As you get heavier, stand against the wall for balance while performing this asana.

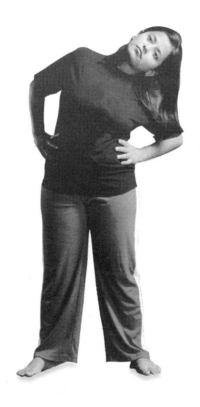

Virabhadrasana or Warrior Pose

The 'warrior pose' stretches and tones your pelvic area, arms, shoulders and legs.

- Stand with feet placed 60 cms apart, and parallel to each other. Turn your right foot to 90 degrees and place your left foot inwards at an angle of 45 degrees.
- Extend your arms to your sides, parallel to the floor.
- Exhale, bend your right knee gently and lunge forward, keeping the torso facing forward.
- If you are holding the posture, then breathe normally.
- Slowly return to your upright position, releasing the posture. Now repeat the same steps with your left side.

Repeat 1 to 2 times.

Balancing may be difficult as your abdomen grows. You could perform this asana *by taking the support of a wall.*

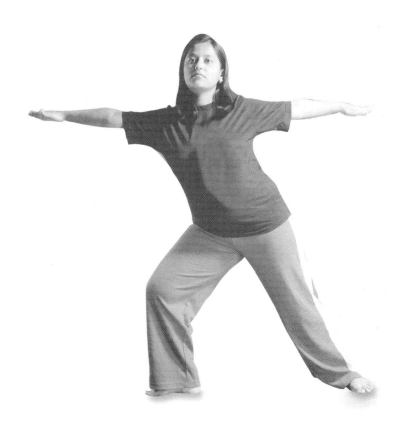

UTTANASANA OR SQUAT POSE

This *asana* provides furthers flexibility to your hips and pelvic and strengthens the muscles of the uterus, knees and thigh.

- Stand with your feet 60 cms apart. Slowly bend your knees and lower your hips to a squat position in which you feel comfortable.

- Join your palms and touch your elbows to the inner sides of your knees, giving a slight push.

- Stay in this position for a few seconds or as long as you feel comfortable. To release this stance, simply place your fingers on the floor and slowly bring your hips to the floor.

Repeat 2 to 3 times.

For additional support, perform this asana *against the wall. If you are not confident of doing this posture, do not attempt it.*

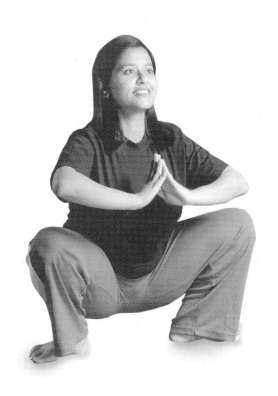

Ardh Matsyendrasana or Half Spinal Twist

This *asana* is designed to relax the muscles of the middle and upper torso and give flexibility to the spine. It also tones the internal organs.

- Sit in the cross-legged position with the spine held erect. Place your right hand on the floor, behind your back.

- Keep your left hand on your right knee and turn your neck so that you can look over the right shoulder, thus giving your spine a 'half twist'. Now repeat the same twist on the left side of your body.

- After the sixth month of pregnancy, practise the *asana* in the following manner:

 - Place a chair with its back against a wall. Stand next to the chair with your right shoulder facing the wall.

 - Lift your right foot and place it on the seat of the chair. Place both palms on the wall and look over your right shoulder, giving your spine a gentle twist.

 - Repeat the same on the left side of your body.

 - Inhale with each twist and exhale with release of the posture. If you are holding the posture, then breathe normally.

Try not to force the spine to twist.

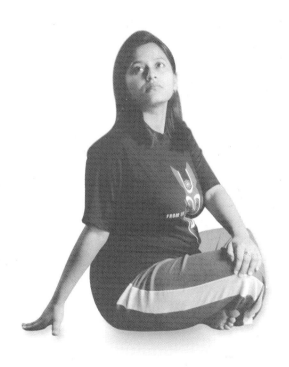

SHASHANK ASANA OR EASY POSE

This *asana* releases stress in the upper part of the back and is great to relax the body.

- Sit on the mat with your hips on the heels. Separate your knees to accommodate your belly.

- Close your eyes and relax for a few seconds, keeping your spine and head straight.

- Inhale. Bend your torso forward from the hip and place your forehead and hands on the floor in front of your knees. You could also use the support of pillows by placing them in front of you and then keeping your forehead and hands on the pillows.

- Stay in this position for as long as you feel comfortable, breathing normally. Release the stance by slowly raising your torso and relaxing.

- Repeat as often as you find it comfortable to do so.

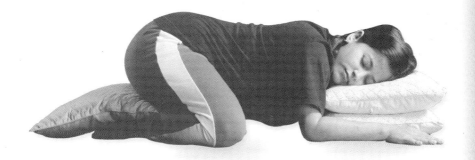

BALASANA OR CHILD POSE

This *asana* is the best position to relax the whole body.

- Lie on your right side. Place a pillow under your head. Bend your left knee a little towards your chest.

- Place pillows under your bent knee. Close your eyes, take a deep breath or too and relax your entire body. Stay in this position as long as you want.

- Repeat the same on your left side.

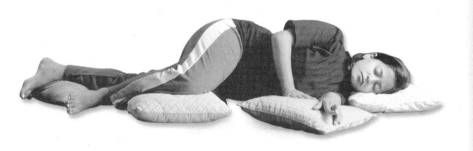

Pranayama or Yogic Breathing

Breath is the very essence of life. According to the yogis, there are two main functions of breathing. The first is to oxygenate the blood and the second is to control the *prana* or vital energy, leading to control of the mind.

Pranayama or yogic breathing is very important in yoga. In the *yoga sutras*, the practice of *pranayama* and *asana* is considered to be the highest form of purification and self-discipline for the mind and the body. In *pranayama* we focus attention on the breath. Therefore, it is very important to keep an alert mind. There is no movement in the body as in the practice of *asanas*, but we must feel the movement of the breath within as *pranayama* prepares us for achieving stillness— a prerequisite of meditation.

Just as there are three stages in an *asana*, in *pranayama* there are three parts to each breath — inhalation, retention and exhalation. Unlike the general belief that inhalation is the most important part of breathing, yogic breathing focuses on prolonged retention and exhalation. Nasal inhalation maximizes the amount of *prana* taken

in, for at the back of the nose lie the olfactory organs through which the *prana* passes, to reach the central nervous system and the brain.

Yoga breathing exercises teach you how to control the *prana* and thus control the mind. Since breathing reflects your state of mind, by controlling your breathing, you can control your state of mind. The increased intake of *prana* will bring you great vitality and strength. It also steadies your emotions and encourages greater clarity of mind. In order to facilitate the flow of *prana*, all yogic breathing exercises are performed while sitting down with the spine, neck and head held in a straight line. Always try to be aware of the breath, and focus on a place in the body where we can feel or hear the breath entering and leaving the body at the nostrils. It is also possible to listen to the breath, specially if you make a slight noise (*ujjayi pranayama*).

During pregnancy, yogic breathing is extremely beneficial as you are breathing for the two of you. You need an abundant amount of oxygen to pass it on to your baby, so that it develops into a healthy, strong infant. *Pranayama* will help control pregnancy anxieties and promote a feeling of calmness and well-being during your entire gestation period. It also proves beneficial during labour as it helps you cope with the painful muscular contractions and calms you, so that your delivery is smooth and natural.

Whilst performing breathing exercises, do remember to sit up in a comfortable position, supporting yourself with cushions, keeping

your facial muscles released and breath natural. Also remember not to retain your breath and stop the exercise if you feel breathless.

'Breathe naturally, without forcing. No pressure, no disturbance. Nothing should interfere with the simple tide-like movement of our lungs as we breathe in and out.'

—Vanda Scarvelli

Nadi Shodhan or Alternate Nostril Breathing

In this *pranayama*, the blood receives a larger supply of oxygen than in normal breathing; your mind feels relaxed and calm. It also soothes the entire nervous system.

- Sit in a comfortable cross-legged position. Relax your entire body and keep your eyes closed.

- Bend your right arm from the elbow. Bend the middle and index finger inward to your palms. Bring your ring finger and the little finger toward your thumb.

- Place your right thumb on the right side of your nose and your ring and little finger on the left side of your nose. By pressing your thumb, block the right nostril.

- Inhale slowly and deeply through your left nostril. After full inhalation, block your left nostril with your ring and little finger. Exhale, breathing out the pressure from your right nostril and releasing the air slowly, deeply and steadily.

- Next, blocking your left nostril, inhale deeply from the right. After a full inhalation, block the right nostril and exhale, releasing the pressure from the left nostril slowly, deeply and steadily. This completes one round of the *pranayama*. Try to do four to eight rounds at least twice a day.

- Lie down in *balasana* and relax.

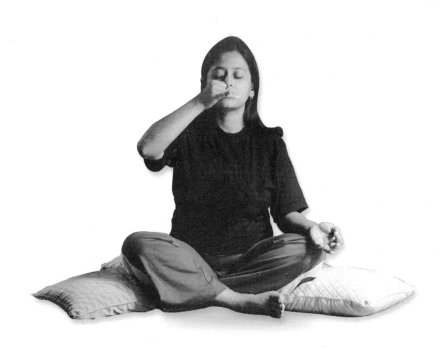

Ujjayi Pranayama

This *pranayama* increases your endurance level, soothes your nerves and tones your entire nervous system. It prepares you well for labour as it helps you to stay calm during the entire period.

- Sit in a comfortable position with eyes closed. Relax your body and breathe.

- Inhale deeply from both nostrils through the throat, partially keeping your glottis closed in order to produce a sound of low uniform pitch (*sa*).

- Fill your lungs, but take care not to bloat your stomach. Exhale slowly and deeply until your lungs are empty. As you exhale, the air should be felt on the roof of the palate and make a sound (*ha*). These sounds should be so silent that only you should able to hear them. This completes the first sequence of this *pranayama*. Wait for a few seconds to begin the next round.

Repeat 10 to 15 times.

Bandha and *Mudra*

B*andha* and *mudra* are the locks and seals that have a powerful effect on the reproductive organs of a woman. They also help in altering the mood, attitude besides enhancing awareness and concentration. We have featured two of the most important and beneficial exercises here.

Moola Bandha or Pelvic Floor Exercise

Exercising the pelvic, anal and vaginal muscles keeps them strong and flexible, as these muscles are gong to stretch fully at the time of the birth of your baby. They have to withstand the pressure and the stress of birth and return to normal position, avoiding any postnatal problems.

- Sit in a comfortable cross-legged position, with your eyes closed and your body relaxed.
- Focus on your anal sphincter, the perineal muscles and the vaginal area.
- Inhale. Contract these muscles. Exhale and release these muscles.

Repeat several times.

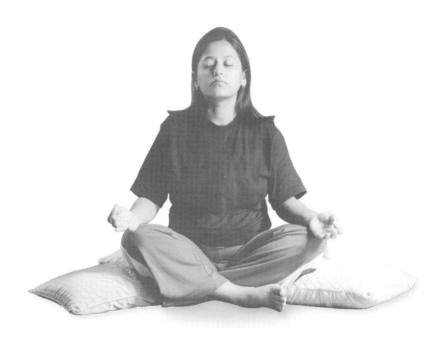

Yoni Mudra or Womb Seal

This *mudra* is helpful in soothing your mind and the nervous system. It helps you to withdraw yourself from the outer world and enter your inner world. This practice provides the peace needed to prepare you for your new stage of life.

- Sit in a comfortable position; relax your body and focus on your breath.

- Raise your arms and cover your face gently.

- Place your index finger on the eyebrow, and your middle finger on your closed eyelids. Press the tips of your ring finger on the outer side of the nostril and your little finger on your lips at the corner of your mouth. Press your thumbs on your ear-holes to withdraw from all the sounds.

- Breathe normally and remain in this position for as long as you feel comfortable. Then lie down in *balasana*.

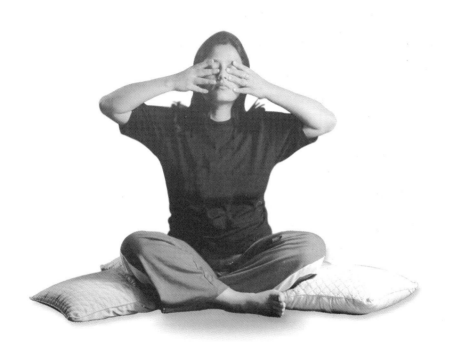

Meditation and Relaxation

Everyone seeks peace of mind though the path adopted to achieve it may differ. Some use soft soothing music to ease the tensions of the day, some read quietly and still others find solace in prayer. The purpose of all these activities is to focus attention on any one point of concentration and still the mind, shutting away all other thoughts till the incessant internal chattering stops. As the mind calms down, and the worries get forgotten, there arises a feeling of contentment. With continued practice of meditation, you can discover a greater sense of purpose and strength of will. Your thinking becomes clearer and more concentrated, affecting all that you do.

Pregnancy is wonderful but it can be a period of strain and stress; striking a harmonious balance between the mind and the body under these circumstances can be rather difficult.

The meditation and relaxation techniques taught during the yoga class help you to cope well with the various mood swings that one suffers during pregnancy. These mood swings are due to the hormonal changes that take place during your first trimester. Hormone

fluctuations are greatest in this period due to the changes in the levels of estrogen and progesterone. This causes emotional disturbances, nausea and a feeling of lethargy.

After the three-to-six month period, your placenta replaces the ovaries, which produce the harmones—oestrogen and progesterone. As these hormonal levels reach a balance, your energy levels return and your emotional swings diminish.

In the last trimester, another major change takes place in your body as it prepares itself for labour and lactation. After your baby is born, the oestrogen and progesterone levels fall once more, causing extreme depression and fatigue.

Meditation and relaxation techniques help you cope with all these hormonal imbalances and emotional ups and downs. They also keep the mind calm, focused and well balanced, besides creating a positive state of mind. Now you are at the stage to willingly accept the changes taking place in your body and in your life.

Meditation is only a path to increasing your self-awareness and connecting to your unborn baby. It is a proven fact that mothers who practise yoga during their pregnancy give birth to babies who are of happy disposition, calm, healthy and flexible. Your nine-month journey through pregnancy will be a lot more easy with meditation as you focus your energies on creating another life within you.

In order to get the maximum out of meditation, it is essential to make it a regular habit in your life. If you follow these simple instructions, you will be able to gradually train your mind to respond without delay.

- Identify a special place for meditation, where you can be left undisturbed for a period of time.

- Ideally the best time to meditate is early dawn or dusk, when the atmosphere is charged with spiritual energy. If neither of these times is suitable, then choose a time when you can concentrate wholly on meditation.

- Use the same time and place each day, as this will train your mind to slow down more quickly.

- Sit with your back, neck and head held in a straight line, facing the north or east, to benefit from the subtle effects of the earth's magnetic field.

- Try to keep your mind calm during the meditation sessions, by forgetting the past, the present and the future.

- Regulate your breathing by first slowing it down and then establishing a rhythmic pattern. This will control the flow of *prana* and help you to still your mind.

- Practise meditation daily, starting with twenty minutes and gradually increasing to an hour.

'Meditation gives you what nothing else can give.
It introduces you to yourself.'
—*Swami Rama*

JAPA MEDITATION OR MANTRA MEDITATION

Sound is a form of energy that is made up of vibrations and wavelengths. *Mantras* are Sanskrit syllables, when chanted, will take you to a higher stage of consciousness. Sincere practise and repetition of a *mantra* lead to birth of pure thought. *Japa* meditation calms the body and mind. It induces a state of silence and stillness. The vibration of the chant has a very soothing and positive effect on you and your baby.

- Sit in a comfortable cross-legged position with the spine held erect, or preferably still, sit against a wall, as you will be more comfortable and less distracted. Cushions and bolsters may also be used as per your needs.
- Place your hands on your knees with palms upward and the fingers in the chin *mudra,* i.e. your thumb pressing the tip of your index finger. Relax your body and calm your breathing.
- Gently focus your eyes on the point between your eyebrows—the *ajna charka.*
- Feel your breath moving in and out of your body. Visualise that from this point you are sending all your energy to your baby.
- Now chant a *mantra* or the cosmic sound, *OM*. First chant loudly for a few seconds, and then slow it down to a whisper that you only can hear. Then chant it mentally 108 times. (You could also use a *japa mala* to keep a track of the counts).
- Continue till you are comfortable and then lie down in *balasana.*

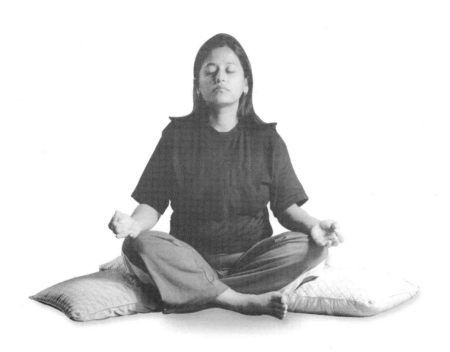

Yoga Nidra or Relaxation

The state of our minds and the state of our bodies are intimately linked. If our muscles are relaxed, then our mind too is relaxed. In today's world, we are bombarded with stimuli that leave our bodies in physical and mental tension. Such undue tension drain us of our energy and becomes the major cause of our tiredness and ill health.

Relaxation releases the muscular tension, infusing the body with serenity. To relax is to rejuvenate. To rejuvenate is the key to good health, vitality and peace of mind. Yoga *nidra* is a gentle relaxation technique that requires a few minutes and is very effective in our day-to-day lives.

- Lie down in *balasana* and make yourself comfortable. Relax your body and focus on your breathing.

- Relax your body physically by mentally starting from the toes and moving upwards slowly, till your entire body is relaxed.

- Your mind can be relaxed by focusing on your rhythmic breathing and letting no other thought to creep in.

- Stay in this position for as long as you want.

72

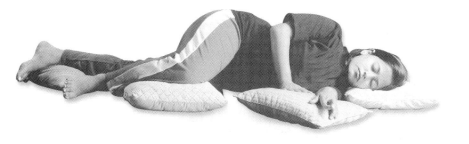

9

Pregnancy and Diet

Throughout your pregnancy your baby is dependent on you for all its dietary needs. This means that you should pay special attention to what you eat. A poor diet during pregnancy will not only take its toll on your own health, but can also have life-long repercussions on the physical and mental well-being of your child.

A pregnant woman should eat a well-balanced diet, but at the same time keep track of her weight gain. Women who experience morning sickness or nausea in the first trimester are sometimes unable to eat properly. In fact, many mothers-to-be tend to lose weight during this period. However, this should not worry the expectant mother, unless it continues even after the third month; then it becomes advisable to seek the doctor's help. Food aversions are extremely common in pregnancy and are believed to be due to the hormonal changes taking place in the body.

From the third month onwards, when your baby starts to develop and grow, you will find a change in your appetite. Your hunger will return! This is the time to nourish yourself with a well-balanced and nutritious diet. It is important that women should gain

weight during pregnancy. Not gaining enough weight makes for a low-weight baby who might face health problems; on the other hand, too much weight may make the delivery a bit too difficult. The ideal weight gain during your pregnancy is between 9 to 13 kg. Any weight gain beyond this will stay with you after your delivery. Make sure not to restrict your diet during pregnancy because otherwise your diet may lack the right amount of nutrients required for the growth of the baby.

Remember to
- Eat small portions of food at regular intervals. Avoid consuming large quantities of food at meal times.

- Keep fruits, nuts and biscuits handy for those intermediate hunger pangs.

- Avoid smoking (including passive smoking) and alcohol.

- Reduce your intake of tea and coffee.

- Avoid heavy and spicy foods as these may cause flatulence. Keep your salt intake low.

- Eat at least two portions of fruits and vegetables.

- Avoid aerated drinks as this will lead to unwanted calories. Instead, substitute with fresh fruit and vegetable juice.

- Add honey instead of refined sugar to your milk. And in general, limit all kinds of sugar.

- Eat only when you are genuinely hungry.
- Eat slowly and chew your food well.
- Avoid tranquillisers and drugs in general, unless you are prescribed one by your doctor/gynaecologist. If you have an overpowering need to take a drug, then consult your doctor. Just remember that drugs have serious effects on the unborn foetus.

A Balanced Diet is a Must!

We are what we eat, and a diet based on fresh, light, nutritional foods, such as fruit, vegetables and grains keeps the body lean, agile and the mind clear and sharp. For you, as a pregnant mother, this is even more vital as your health and vitality will determine the health and vitality of your unborn child. Your diet should contain adequate quantities of proteins, minerals and vitamins for both a healthy you and your baby.

Protein is required during pregnancy to support the growing foetus and the placenta. It can be obtained in generous amounts from lentils, peas, beans, nuts and soya products. These can be taken in combination with whole grains such as wheat, oats, corn, barley, etc. It is better to avoid red meat as it could lead to constipation. Besides, meat only adds toxins to the body.

Calcium is required at every stage of pregnancy as it helps in the development of your baby's bones and teeth. Women should increase the intake of calcium during pregnancy in order to meet the foetus'

needs without compromising their own bone density. Deficiency of calcium can lead to weakness and acute pain in the bones and joints of the expectant mother, making it difficult to carry on with the pregnancy. Deficiency of calcium can ultimately lead to development of rickets in your growing child. Good sources of calcium are soya, nuts and dairy products like milk, curd, cottage cheese, soya and nuts.

Iron and Folic Acid

Iron is necessary for the development of haemoglobin — the carrier of oxygen in the blood. Haemoglobin is attached to red blood cells and it is because of this component that oxygen is able to move from the lungs to different parts of the body. Deficiency of haemoglobin results in anaemia, which subsequently leads to weakness, breathlessness and fatigue. Dietary sources of iron are green leafy vegetables, egg yolk, raisins, apricots, cereals, whole grain, bread and liver. Folic acid is easily available in jaggery, pulses and dairy products.

Vitamins

Vitamins promote good eyesight, healthy teeth, clear skin, and general growth and vitality. They build resistance to infection and are very necessary during pregnancy and lactation. Natural sources of vitamins are fruits, milk and milk products and vegetables. Vitamins C and D increase resistance to infection and hold the body

cells together. Vitamin C is available in citrus fruits, papaya, mango, tomato, potato as also in minor amounts in other fruits and vegetables. Vitamin D is available from sunlight and natural fruits and vegetables that are full of this *prana*.

Fibre

A very important component in diet during this period, as pregnant women normally tend to suffer from constipation due to the extra intake of iron. Try and eat lots of fruits and vegetables, whole grains and cereals to add fibre to the diet. Fibre is rich in polyunsaturated fats that help control blood cholesterol.

Liquids

Equally important is intake of plenty of fluids. Drink lots of water and fresh juices, but limit your consumption of tea, coffee and aerated drinks. Drinking fruit juice or herbal tea is definitely preferable to drinking plain tea. We do not recommend alcohol to pregnant mothers. Not only does it get absorbed into your bloodstream, and that of your baby, you also run the risk of suffering from slower reflexes and loss of muscle coordination, thus placing both yourself and your baby at risk.

> *'Let thy food be thy medicine and medicine thy food.'*
> —**Hippocrates**

10

Yoga for Conception

So you are planning to start a family. Then you must know that the implications of bringing a child into this world are enormous—not only on you as a mother-to-be, but on your partner and on your lifestyle as well. But if the timing is right, and you are mentally prepared, then you should start preparing your body for pregnancy at least a year in advance.

Time and again it has been proven that stress is one of the biggest blocks to getting pregnant. In this busy world it becomes harder to find the inner peace that our body and mind craves for. Yoga is a mind and body exercise that enables you to recharge at all levels and allows your body and mind to work with its innate magic.

Start on a protien diet and increase your intake of green vegetables and fruits, reducing fried and junk food, thus cleaning your body of toxins. Those of you who have been on a contraceptive pill, give yourselves three months without it to let your body get used to the new situation. Visit a gynaecologist and make yourself familiar with what is going to happen. It is important that you get yourself

checked for Rubella virus. Take special care of yourself so as to make your baby's stay comfortable.

The way to approach your conception is to create the correct environment for becoming pregnant, which means that as a prospective parent, your body must be in optimum health and in fit condition to facilitate conception. In addition, your mind must be calm and positive. Time and again it has been proven that stress is one of the biggest blocks to getting pregnant.

The result of a balanced yoga session will give you tranquility of mind and the body will feel rested and energized . Your internal organs will feel recharged and this will allow them to function more effectively. Therefore if you are having trouble conceiving you should give yoga a try. By starting early, you will develop all the good habits that are essential to carry, protect and nourish your unborn child when the time comes.

The regular practise of *hatha* yoga will help achieve hormonal balance, regulate irregular menstrual cycles and tone all the reproductive organs. Yoga postures foster awareness of feelings, both physical and emotional. They build strength and flexibility and also help in lubricating the joints and in releasing the toxins that build up in the body. The various postures also tone the muscles of the spine and strengthen the entire physical body—internally as well as externally, making it fit to carry a new life inside it for nine months.

The *asanas* described in this section should be done before one decides to conceive. Once you become pregnant, you can make

changes and add new *asanas* that will help and support you through your pregnancy.

> *'Meditation does not come easily. A beautiful tree grows slowly.*
> *One must wait for the blossom, the ripening of the fruit and the*
> *ultimate taste. The blossom of meditation is an expressible peace*
> *that permeates the entire being. Its fruit is indescribable.'*
> —*Swami Vishnu-Devananda*

AGNI SARA OR ENERGISING YOUR SOLAR CENTRE

This exercise tones your abdominal muscles and organs. It encourages digestion and excretion. It also tones all your reproductive organs and facilitates sexual functions.

- Sit in a comfortable cross-legged position.
- Place your hands on your knees, close your eyes and relax your body for a few minutes.
- Inhale deeply. Exhale, by emptying out your lungs completely.
- Lean forward a little and straighten your elbows, pushing down on your knees.
- Lower your chin down towards your throat. Now contract and expand your stomach muscles rapidly for as long as you can hold your breath.
- Perform about five to ten contractions in this way, but *do* not strain yourself.
- Slowly lift your head up, inhale slowly and deeply.
- This completes one round. Relax your body, breathe and begin the next two rounds.

Do not practise this when menstruating, or if you are suffering from heart disease, high blood pressure, hernia or an ulcer.

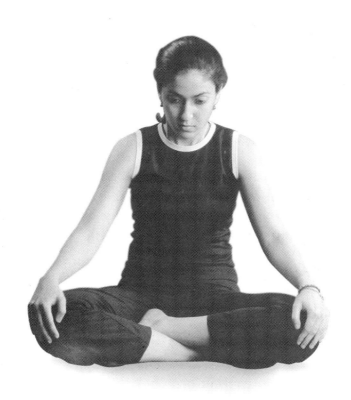

Sarvang Asana or Shoulder Stand Pose

This *asana* balances your endocrine glands to your hormonal levels. It regulates menstrual activity and also is very beneficial for women suffering from a displaced uterus.

- Lie on your back and flex your toes inward. Place your palms facing down, close to your hips. Inhale; push down on your hands and raise your legs straight up and above you.
- Lift your hips off the floor and bring your legs up, over and beyond your head at an angle of about 45°.
- Exhale, bend your arms and support your body, holding as near the shoulders as possible, thumbs around the front of the body, fingers around the back. Push your back up and lift your legs.
- Straighten your spine and bring the legs up to a vertical position. Press your chin firmly into the base of your throat. Gradually try to get your elbows closer together and your hands further down your back, towards the shoulders, so as to straighten your back.
- Breathe normally while doing this posture and while holding it. Stay in this position 20 to 30 seconds.
- Bend your knees and pull them to your forehead or chest; then gently lower your body, releasing the position.

Take care not to jerk into the posture instead gently keep pulling your body up into the final position.

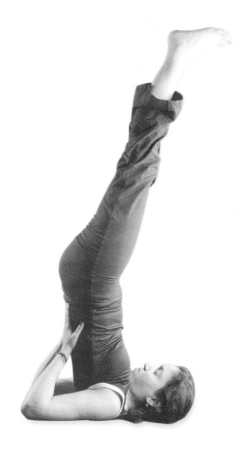

Parvatasana or Mountain Pose

This *asana* makes the entire body strong. The abdominal muscles are drawn toward the spine when breathing deep. It strengthens the internal organs and has a profound effect on the reproductive organs.

- Lie down on the floor on your stomach, i.e. with your face downwards. Keep your feet about 2.5 cm apart.

- Rest your palms by the side of your chest, with fingers straight out, pointing towards your head.

- Exhale. Raise your hips, lowering your head between your arms. You will be forming a triangle with your back and legs.

- Try to keep your legs stiff. Do not bend your knees but try to press your heels and the soles of your feet on the floor. Also try to bring your head towards your knees.

- Stay in this position for thirty to forty seconds while breathing deeply.

- Release the posture by lifting your head forward, stretching your torso forward and lowering your body gently down to the floor.

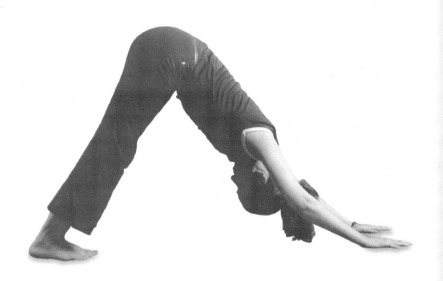

Upavistha Konasana or Full Leg Stretch

This posture stretches the hamstring muscles and tones the pelvic region. It controls and regularises the menstrual flow and stimulates the ovaries. It is an excellent exercise for the women.

- Sit on the floor with legs held together and stretched straight out in front.

- Separate your legs sideways, one by one, by widening the distance between them as far as you can while ensuring that the back of your legs rest on the floor. Stretch your toes inward.

- Turn your torso towards the right and raise your arms up.

- Exhale. Bend forward towards your right foot with both your hands, till you rest your chin on your right knee. Stay in this position for a few seconds.

- Inhale. Slowly raise your arms again, then your head and torso till you are back in the starting position.

- Repeat the same sequence on your left side.

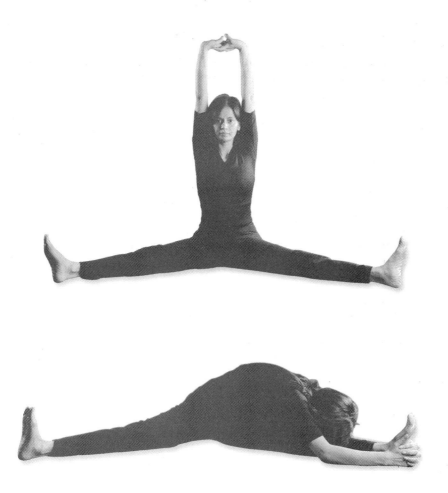

JANUSHIR ASANA OR HEAD TO KNEE POSE

This *asana* tones up your pelvic organs, and you develop flexibility throughout your pelvis.

- Sit with your legs stretched out and feet kept together.

- Bend the left knee and place the sole of your left foot against the inner thigh of the right leg. Keep your left knee on the floor.

- Keep your spine straight. Close your eyes in this position. Relax your body.

- Inhale deeply, and raise both your hands straight up.

- Exhale. Bend forward and slide your hands down to your right leg. Hold on to your right foot, or if possible, to your big toe.

- Inhale. Come up slowly, releasing the posture.

- Repeat this two to three times on the right side. Then repeat the same on the left.

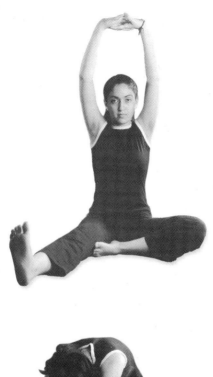

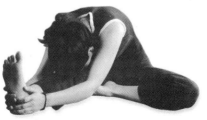

YOGAMUDRASANA OR PSYCHIC UNION POSE

This *asana* massages the abdomen and tones up all the internal organs, including the reproductive organs.

- Sit in a comfortable cross-legged position. Relax your body until your breathing becomes normal.

- Place both hands behind your back. Hold one wrist with the other hand.

- Inhale deeply and then exhale. Bend forward, keeping your spine straight.

- Touch your forehead to the floor or, if not possible, get as close to the floor as you comfortably can.

- Relax the entire body in this final position. Breathe deeply. Hold this position for twenty to thirty seconds.

- Inhale and return slowly to your starting position before relaxing.

Take care not to strain your back, ankles, knees or thighs by forcing your body to reach the final position.

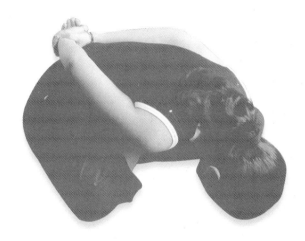

95

SHAVASANA OR DEAD MAN'S POSE

This *asana* releases fatigue and tension from the body. It is also a great stress releaser.

- Lie down on the floor on your back, with your legs stretched out and your feet slightly apart in a comfortable position.

- Place your arms at the sides of your body, but slightly apart. Keep your palms facing upwards.

- Keep your head and the spine relaxed.

- Relax your entire facial muscles. Keep your eyes closed.

- Relax your entire body, ensuring that no part of your body is tense.

- Allow your breath to become rhythmic.

- Stay in this position till your whole body is completely relaxed. When this happens, you will experience the feeling of being separated from your body.

- Stay as long as you want in this position.

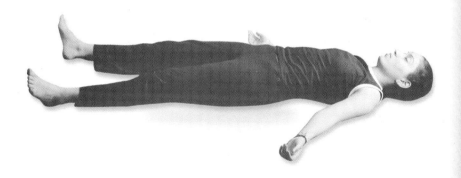

Working Women's Module

Many women work during pregnancy, and continue to work till the time of the delivery. Your decision to work during pregnancy should be based on your own personal situation and desire. There is no proven reason why you should not work while pregnant, provided you take some precautions to keep yourself and your baby healthy and safe.

Rest is important, as it helps to maintain the blood flow to the baby growing inside your body. So you should cut down your working hours as far as possible and avoid particularly stressful, intensive duties during this period. Avoid heavy physical work and commuting long distances. Try to keep away from potentially hazardous substances like chemicals, fumes or radiation. Take frequent breaks, make frequent position changes and keep your feet up several times a day. Take special care of your diet as you need to be fuelled up for the day. Wear comfortable clothes and shoes, and sit on a chair that provides good support to your back.

If you choose to work during your pregnancy, you need to take special care, especially if you have to attend to household chores in

addition to that of your workplace. Yoga is the perfect way to de-stress your body and tone up your muscles, even while at work! We have put together a set of *asanas* that are simple and quick, and can be done during your workday. The exercises will make your tiredness disappear, and make you feel rejuvenated.

> *'May our outward actions conform to our inner thoughts.'*
> —**Athvara Veda**

Quick Office *Asanas*

Our working woman yoga module takes into consideration the paucity of time, keeping in mind your workplace infrastructure and routine. The entire sequence of exercises should not take more than twenty to twenty-five minutes.

Netri Sakti or Eye Exercises

This exercise removes the stress and tiredness out of your eye muscles. It is very reviving and its regular practise can improve your eyesight.

- Sit on your chair in a relaxed comfortable posture. Keep your eyes open.
- Blink your eyes ten times rapidly. Relax.
- Then close your eyes for a few seconds. Repeat the blinking ten times again.
- Now repeat the whole sequence at least four to five times.
- Rub your palms together and place them on your eyes. Gently open your eyes in your palms.
- Lower your hands down and relax.

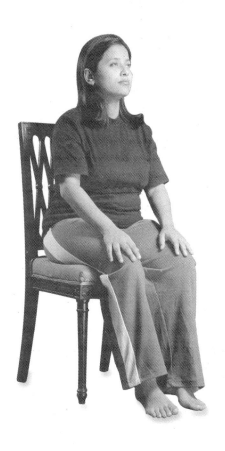

GULPHA SAKTI OR ANKLE ROLLS

Your feet and ankles are prone to pressure and tiredness during pregnancy. This simple *asana* releases the tension in your ankles and the toes.

- Sit in a chair. Place your right foot on your left thigh and rotate your ankles five to ten times on one side.

- Now, reverse the order. Place your left foot on your right thigh and rotate your ankles.

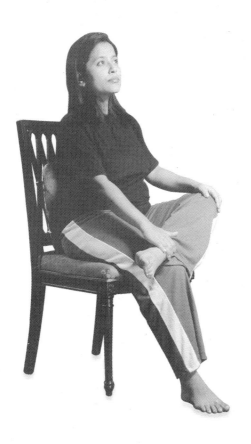

ANGULI SAKTI OR FINGER EXERCISES

This *asana* releases all the tension in the finger joints. During pregnancy your body will retain a lot of fluids in the joints, and this simple exercise can improve circulation in your finger joints and reduce the swelling.

- Sit in a chair and make yourself comfortable.
- Stretch your arms forward, parallel to the floor at shoulder level.
- Open your hands with palms down and stretch your fingers as wide as possible.
- Then close your fingers in a tight fist with the thumb inside, making sure that your fingers are tightly wrapped around your thumb.

Repeat 10 to 15 times.

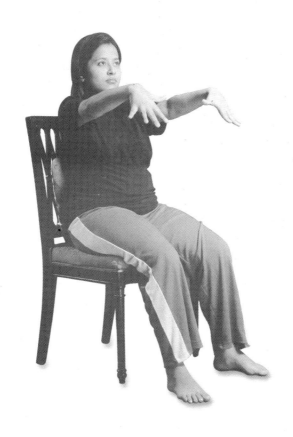

Bhadrasana or *Blessed* *Posture*

This *asana* releases stress and increases your ability to concentrate. It also calms and stabilises your mind.

- Sit in a chair in a comfortable position, keeping your eyes closed. Relax your body for a few seconds.
- Bring both your hands behind your back and place them under your hips, as if you are sitting on them.
- Keeping your back erect and head straight, open your eyes and fix your gaze on the tip of your nose for ten to twenty seconds.
- Close your eyes and relax.

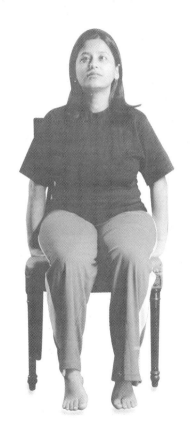

Hasta Uttan Asana or Backward Bend

The 'backward bend' stretches your spine and removes all the tension from your back.

- Sitting in your chair, place both hands behind your back, using your palms to support your back.
- Inhale. Elongate your spine by stretching upwards.
- Exhale. Drop your head backward, giving your spine a good stretch.
- Inhale and come back to the start position.

Repeat 2 to 3 times.

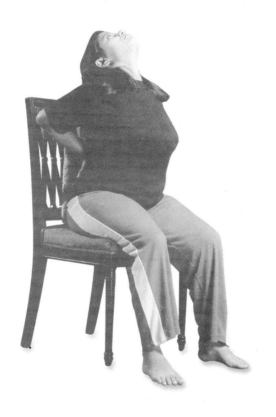

Kati Chakrasana or Waist Rotating Pose

This is a good *asana* to release the tension from your back muscles, spine and neck.

- Sitting in your chair, place your legs a few inches apart.
- Inhale. Raise your left arm to shoulder level and rest your right arm on your seat with palm down.
- Exhale. Turn your torso towards the right.
- Look over your right shoulder and place your left palm on your right knee.
- Stay in this position for a few seconds, before returning to the starting position.
- Repeat the same on the left side. Then relax.

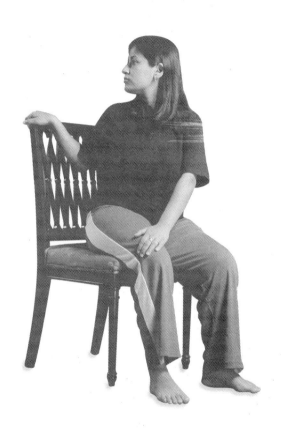

13

Pranayama in a Jiffy

Pranayama or yogic breathing ensures an abundant supply of oxygen and a better life force for you and the baby.

'When the breath wanders, the mind also is unsteady. But when the breath is calmed, the mind too will be still. And the yogi achieves a long life. Therefore, one should learn to control the breath.'
—Hatha Yoga Pradipika

Bhramari Pranayama

This *pranayama* relieves stress and anxiety besides rejuvenating the mind.

- Sit in your chair, keeping your back erect, head straight and your hands resting on your knees.
- Close your eyes and relax your whole body for a few seconds.
- Breathe in through your nose and exhale slowly, making a humming sound like that of the bee.
- Make sure that the humming sound is smooth, even and continuous through the entire exhalation process.
- At the end of the exhalation, breathe in deeply and repeat the process.

Repeat 10 to 15 times.

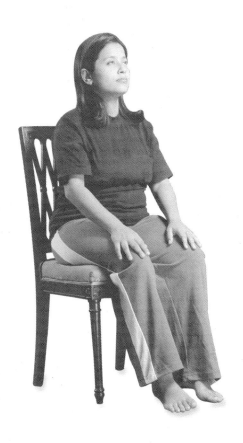

Easy Relaxation and Meditation

- Sit in a chair. Focus your mind by placing all your awareness on your body and mentally begin to relax your body and mind.

- Slowly start concentrating on your breathing. If possible, do *japa* meditation, by repeating a mantra or a nice word in your mind.

'Yoga is the suspension of the modification of the mind.'
—*Raja Yoga Sutras*

15

Having Your Baby: The Final Hours

The last few weeks will seem interminable as you wait for your baby to arrive. Healthy babies seem to decide when they want to put in their appearance, so it's best to remain patient and calm. After nine months of nurturing, a few days here or there should not make too much of a difference.

Your doctors will advise you on the signs and symptoms of the onset of labour. And when the time comes, however, there are no fixed guarantees of how easy or difficult your labour is going to be. If you have opted for natural childbirth, you must be prepared for hard work. Bringing your little one out into the world will certainly not be easy. A normal labour could last anywhere between two to three hours, maybe even twenty-four hours or more! So the only thing that you can do to facilitate the process is to be physically and mentally prepared.

If you have performed the special exercises throughout your pregnancy, your body will be prepared for the time ahead. Regular

practice of the meditation and relaxation techniques listed in this book will keep you calm and focused on the task at hand. An important thing to do is to relax your mind and body as much as possible during the contractions. You are very close to the end of your wait, and your baby is also impatient to come out into the world. Labour is a means to an end, and must be seen in that perspective.

There is no greater joy than finally hearing your baby cry and hold it in your arms. In that instant, you forget the discomfort of labour as this new and magical experience takes over. Even the journey through pregnancy cannot prepare you for the overwhelming love that you feel as you first lay your eyes upon your child.

'Your body is your temple.
Keep it pure and clean for the soul to reside in.'

—*B.K.S. Iyengar*